ALLERLEIRAUH

CINDERELLA

ALL KINDS OF FUR

Erasure Poems & New Translation of a tale from the Brothers Grimm

Margaret Yocom

DEERBROOK EDITIONS

PUBLISHED BY
Deerbrook Editions
P.O. Box 542
Cumberland, ME 04021
www.deerbrookeditions.com

FIRST EDITION
© 2018 by Margaret Yocom
All rights reserved.

ISBN: 978-0-9991062-5-9

Author photograph by Jamie Lynn Photography.

Cover art: *Bear Girl* by Anne Siems.
www.annesiems.com

Book Design by Jeffrey Haste.

For John

A note on the text:

Poems in black font are erasures of the Author's translation of Jakob and Wilhelm Grimms' 1857 tale "Allerleirauh" ("All Kinds Of Fur"), a version of "Cinderella" that opens with incest.

Contents

In what shape
Shall I wait at the breathing hole?

—Qilerniq

I want the moon to overfill, spill over,
 and drown me in dust light.
I want whatever happens after that.

—Jennifer Atkinson

O nce
there was a king
who had a wife
with **golden hair**,

and she was so beautiful that
no one
like her
existed anywhere
on earth.

It happened that she lay ill,
and when **she** felt that she would soon die,
she called the king and spoke:

"After **my** death, if you **inten**d **t**o wed
again, take no one
who **is** not just as beautiful as I am, and
who has not such golden h**ai**r as I have.
This you must **promise** me!"

After the king promised her this,
she **close**d
her eyes and died.

For a long time,
the king could not
be consoled, and he would not let
himself even think about taking
a second wife. Finally
his councillors spoke: "It cannot be
otherwise:
the king must wed again

so that we will have a queen."

Now, messengers were sent far and wide
to find a bride whose beauty would match
that of the dead queen completely. But
in the entire world, there was no such a one
to be found. And even if they had

found one, there was certainly no one

who had such golden hair.

So, the messengers returned home,
their task unfulfilled.

3/4

Now the king had a **daughter**.

She was just as beautiful as her dead **mother**

and also had **such golden hair**.

Once,

when **she** had grown up,

the king looked at **her** and saw

that **she** in every way was like

his dead **wife**,

and suddenly he felt an intense, hot-tempered

love

for her.

Then he spoke to his councillors:
"I shall marry my **daughter** because
she is the very image of my **dead wife**,
and because I can find no **other bride**

who is her equal."

When the councillors heard that,
they suddenly became frightened
and spoke: "God has forbidden that
a father should marry his daughter.
From sin nothing good can **come**,
and the **kingdom**

will **be drawn**
with you **into ruin**ation."

7/8

The daughter was even more frightened
when she heard her father's
decision, but she hoped
she could yet turn him away
from
his plan.
So she said to him,
"Before I grant
your wish,

I must first have three dresses:
one as golden as the sun,
one as silver as the moon, and
one as brilliant as the stars.

Furthermore,
I demand
a mantle pieced together from
a thousand kinds of pelts and fur,
and every animal in your kingdom must give a piece
of its skin for it.

But she thought, "Getting such a mantle
is quite impossible, and
this way, I will

 turn

 t urn

 rut n

 Tür **n**

 run t

my father from his evil thoughts."

The king did not give up his idea.
And the most skillful maidens in his kingdom
had to weave the three dresses,

one as golden as the sun,
one as silver as the moon, and
one as brilliant as the stars.

And his hunters had to **catch** all the animals
in the whole kingdom and **cut** off a piece
of each one's **skin**. From that, a mantle

of a thousand kinds of fur was made.

Finally, when
everything was finished, the king
had the mantle brought to him. He spread it out
in front of her and spoke: "Tomorrow

shall be the wedding!"

Now, when the king's daughter saw that
she could no longer **hope** to bring about a change
of heart in her father, she made up her mind to flee.

In the night, while everyone
slept, she got up and took,
from among her treasured possessions,
three things:

a gold ring,
a little gold spinning wheel, and
a little gold reel.

The three dresses of
the sun, moon, and stars
she put in a nutshell.

She put on the mantle
of all kinds of fur, and blackened
her face and hands with soot.

Then she commended herself
to God and
walked away.

She walked
the entire night until
she came to a great forest

and because she was tired
she sat down
in a hollow tree
and
fell
asleep.

The sun rose,
and she slept on.
And when it was broad daylight,
she was still
asleep.

19/20

Now it just **so** happened that the king
to whom this forest **belonged** was out hunt**in**g there.
When his dogs came to the tree,

they sniffed **it**

and ran **rings around** it,

barking loudly. "Go see what **kind** of **game**

is **hid**ing there," the king
comm**and**ed his hunters.
The hunters did as he bid them,
and when they returned,
they said, "In the hollow tree lies a weird animal,
the likes of which we have never seen. Its skin
is made of a thousand kinds of fur. It is
just lying there—asleep."
"Try and see if you can capture it alive,"
the **k**ing commanded. "Then tie it down
on top of the wagon, and take it along."

When the hunters touched the girl, she
awoke terrified and called out to them:
"I am a poor child, forsaken
by father and mother.

Have pity on
me and take me
with you."
"All Kinds Of Fur,

you are just right for the kitchen.
Come along, then,"
the hunters commanded.
"You can sweep up

the ashes."
So they set it on the wagon
and drove it home
to the royal castle.

There
they showed it to a little stall
under the stairs where

no
daylight
ever

came.
"Little Hairy Animal,"

they said,
"you can live
and sleep here."

Then they sent it to the kitchen
where it carried
wood and water, tended
the **fire**, plucked
the poultry, sorted
the vegetables, swept up
the **ashes**, and did all
the lowliest work.

For a long time,
All **Kin**ds Of Fur **live**d
in this mean and shabby way.

Alas,
you beautiful
king's **d**aughter!
What will bec**ome** of you!

Now, **one** day it **so** happened
that a ball was held in the **castle**, an**d**
she said to the cook, "**May** I go
upstairs for a **while and watch**?

I will st**a**nd
out**side** the **door**."
"Yes, g**o on up**," the cook an**s**wered,

"but you mu**st** be back h**ere**
in half an hour

to sweep up
the ashes." So
she took her little oil lamp,
went into her little stall, .
took **off** the fur mantle, and
washed the soot off her face and **hands**;
and so her **full** beauty
came to light again. Then

she **open**ed
the nut**shell** and brought forth
her dress that shone like the sun.

And when that was done,
she went up to the ball.

Everyone stepped aside for her

because no one knew her,

and they could think nothing else but that this

was a king's
daughter.
The king, however,
came towards her,
gave her his hand, and

danced with her.

He thought in his heart: "My
eyes have never
beheld someone as beautiful as she!"
 When the da-

 nce was over,
 she bowed, and, as the king looked

around, she disappeared,
and no one knew where
she had gone. The sentinels

who were standing in front of the castle were summoned

and questioned,
but no one

had seen her.

She, however,

had run to

her little stall, **swiftly** taken off

her dress, blackened

her face and hands, put on

the fur mantle, and was once again

All **Kind**s Of **Fur**.

Now, when she came into the kitchen
to resume her work and sweep up

the ashes, the cook said,
"Leave it be until tomorrow
and, instead, cook the king's
soup for me. I would also like
to look on a little
upstairs, but
don't you let a single hair
 fall in the soup,

or else, in the future, you
will not get anything to eat."

So the cook went away,
and All Kinds Of Fur cooked the soup
for the king, a bread soup,

And when the soup was ready,

All Kinds

Of Fur got from its little stall
its gold ring, and

laid it

in the bowl into which the soup
was to be

poured.

When

the ball was over, the king had the soup
brought to him,
and he ate it all.

It tasted so good to him
that he thought he had never
eaten better soup.

But when he got to the bottom,
he saw a gold ring lying there,
and he could not

figure out
how it had gotten there. So

he gave an order
for the cook to come before him.
When the cook heard

the order, he took fright and
said to All Kinds Of Fur, "You

must have let a hair fall in the soup.
If that's so, you are going to get
a beating."

When he appeared before the king,
the king asked

who had cooked the soup.

The cook answered, "I cooked it."

But the king said, "That is not true.

It was cooked differently

and in a much better

way than usual."

He answered: "I must confess

that I did not cook it.

The Little Hairy Animal did."

The king spoke:
"Go, and have it come up here."

47/48

When All Kinds Of Fur came, the king asked,

"Who are you?"

"I am a poor child who
no longer has a father and mother."

He kept on asking:
"For what purpose are you in my castle?"

It answered: "I am good for nothing—except
for having boots thrown at my head."

He kept on asking:
"Where did you get the ring that was in my soup?"

It answered:
"I know nothing about the ring."

So the king could not find out anything
and had to send it away.

After a **time**, there was

another
ball, **and**

All Kinds Of Fur asked
the cook for **permission**,

like the last time,

to be allowed to **watch**.

"Yes,"
he **answered**, "but

come **back** in half an hour and cook

for the king
the bread soup
he likes to **eat**
so much."

Then,

it ran into its little stall, washed quickly,

took out of the nut
 the dress that was

as silver as the moon, and put it on.

When she went upstairs,
she looked like a king's
 daughter;

and the king stepped up to her
and was happy to see her again.
And just then the dancing began,

and so they danced together.

As soon as the dance ended, though, she

disappeared

 again, so quickly that

the king could not see where she went.

She, of course, ran into her little stall
and made herself again into Little Hairy Animal,
and went into the kitchen to cook the bread soup.

When the cook was upstairs,
it got the gold spinning
wheel and put it in the bowl, so the soup would

cover it. Then the soup was
taken to the King. He ate it,
and it tasted as good to him as the last

time. And he **summon**ed the cook,
who once again had to confess
that **All Kind**s Of Fur **h**ad cooked the soup.

Then All Kinds Of Fur came before the king
again, but she answered that she was only good
for having boots **throw**n at her head,

and that she knew
nothing at all
about **the** little **gold** spinning **wheel**.

When the king held a ball
for the third time, it went no differently from
the times before, except
that the cook said,

"You are a witch, Little Hairy Animal, and
you always put something in the soup

that makes it
so good that it
tastes better to
 the king
 than what I cook."
But because it begged so much,

he let it go up for
the usual time. Now
it put on a dress that

shimmered like the stars
and, wearing it, stepped into
the ballroom.

The king danced
again
with the beautiful maiden
and thought that she had never
been so beautiful.

And while he danced,
he put a
gold
ring on
her finger, without
her noticing

And
he had **given order**s for

the dance to last
a very long time. When
the dance was over, he tried to
hold
 fast
 to her
 hands, but
 she tore

herself **l o o s e** a n d r a n **s** o
quickly into the crowd that she vanished

before
his
eyes.

She ran **as fast as** she could into
her little stall under the

stairs, but because she had stayed
too long, over half an hour,
she could not take off **the beautiful dress,**

and

instead threw
 the mantle of fur over it.

And,

being in such haste, she did
not fully cover herself **with soot,**

and

one finger was left **white.**

Now

All Kinds Of Fur ran
into the kitchen, cooked
the bread soup
for the king, and,

when the cook was
gone,
laid the gold reel in it.

When

the king found

the reel on the bottom,
he had All Kinds Of Fur
summoned.

Then he caught

sight
of her white finger
 and saw the

ring
that he had slipped on it
during the ball.

Then he seized her by
the hand
 and held her fast;
 and, when she tried to get herself

loose and run off,

the fur mantle fell **open**

a **little**,

and the starry **d**ress sh**immered** forth.

The king it off.

 grasped and **r**ipped

 the mantle

Then

her golden hair
appeared, and
she stood there in all her splendor and
could no longer hide. And
when she had wiped the soot and ashes
from her face,
then
she was more beautiful
than anyone
ever
seen
on earth.

Then,

the king spoke:
"You
are my **beloved**
bride, **and** we
will n**ever**
more part from each other!"

Then

the wedding was
c e l e b r a t e d,
 and
 they
 li**v**ed

happily until their deaths.

THE END

Afterword: tale / translation / erasure

> " 'The stories people tell have a way of taking care of them. If stories come to you, care for them. And learn to give them away where they are needed. Sometimes a person needs a story more than food to stay alive.' "
> —Badger, in *Crow and Weasel* by Barry Lopez

One day in 1811, Dortchen Wild told her neighbors Jakob and Wilhelm Grimm a shadowy tale of a young woman who disguised herself in a mantle of rough furs and fled to the woods to escape danger at home. Intrigued, the brothers chose to include it in their first fairy tale collection of 1812; later, Wilhelm chose the young storyteller for his wife.

"*Allerleirauh*"—"All Kinds Of Fur"—tells of a widower king who would marry his daughter. The Grimms, unfazed by the subject of incest, put the tale alongside others that told of unhappy stepmothers who kill their stepsons and serve them up to their fathers as stew ("Juniper Tree"), angry fathers who wish their sons would fly away as ravens ("Seven Ravens"), and poverty-hardened fathers who make rash promises to rank strangers ("Maiden Without Hands").

From the beginning, the brothers edited their tales. They transformed their one-sentence, 1810 summary of "*Allerleirauh*" into a pages-long tale, with the help of other versions they both heard and read. Some readers of the *Kinder- und Hausmärchen* first edition (published in two volumes in 1812 and 1815) were pleased with the tales; some were outraged. So, for their 1819 edition, the Grimms made major changes. As the years passed, the brothers published five more editions, and they kept on editing. They added tales, they took tales away: the first edition presented 156 tales; the final, 1857 edition included 210. In their hands, mothers—such as she of "Hansel & Gretel"—became stepmothers. Magic slipped away, Christian references increased. Violence became more prevalent. And, as sexuality decreased, Rapunzel no longer asked the witch, "Why has my dress become so tight?" In fact, the brothers turned many of their heroines' directly-spoken words into words of indirect speech, relayed by a narrator.

As a poet, folklorist, and storyteller long interested in "All Kinds Of Fur," I wondered what happened to the tale in the hands of other editors and collectors, especially those who did not revise their texts as

extensively as the Grimms did. So, I searched for the story in folktale collections throughout the world. In these tales, All Kinds Of Fur / Cat-Skin / Sack-cloth / Hanchi (Clay Pot) always dons an unattractive body covering, and she appears to others as male or female, human or spirit-world being, or a living entity whose characteristics cannot be discerned. In Palestine, she wraps herself in sackcloth and appears to be an old man or a jinn. In Sudan, she removes the skin from an old man and covers herself. In Japan, she wears frog's skin; in Norway, crow's skin; in Slavic countries, mouse skin. For Romanians living in the Balkans, she turns herself into sea foam.

When she meets the prince or king whom she will later marry, it is not always at a ball. Often, she and the young man compete with each other through teasing, riddles, contests, and games. Voyeurism and cross-dressing enter the tale, here. In Norway, she and the young man race horses; in Sudan, they play *mungala*, a game that resembles chess; in Italy, he secretly watches her undress; in Palestine, he dresses as a woman so he can go to the women-only dance and watch the beautiful stranger. He loses the competitions, he cannot solve the riddles, he looks at but does not truly see the creature whose body he watches. What I learned, above all, through my research was that the young woman uses many creative strategies to save herself and craft a new life.

The Grimms' story texts, though, are the ones the western world knows best; for years, their book sold second only to the Bible. Yet women and men started re-envisioning the brothers' tales as soon as they appeared: in 1843, when the fifth edition of the tales was published, a group of young women in Berlin began a literary salon to write and publish re-visions of fairy tales. And these weren't just any young women, but women whose fathers and mothers had published fairy tales; one of the women married Wilhelm Grimm's son Herman. Their tales featured heroines who found happiness in being educated, adventurous, and single. Many poets and writers continue the work of re-vision today.

I felt a similar tug to revise, but the first step, for me, was to translate the Grimms' "*Allerleirauh*" from the German. All translators interpret the texts they translate, and most of the Grimms' translators have been men. What might I learn if I looked, myself—poet, folklorist, feminist—at the Grimms' words? Plenty, as it turned out. The several discoveries I made more than surprised me; they unsettled me. They changed forever my vision of the tale. For example, All Kinds Of Fur calls herself "*Kind*" ("child") as she hides from men in the woods; yet

almost all translators use the female-identified term "girl." I use "child," though, to point out how All Kinds Of Fur purposefully un-sexes—and protects—herself through her choice of words. For similar reasons, I use the pronoun "it" to refer to All Kinds Of Fur when the text calls for the neuter pronoun (my 2012 book chapter, listed below, relates the details of this choice). Finally, most translators use "princess" for "*Königstochter*" but I choose "king's daughter" because this phrase places her origins, her father's abuse, and her challenges as she rebuilds her life in the forefront of the tale.

As I researched multiple tale versions and translated "Allerleirauh," the tale shifted in my hands. As a poet, I began to wonder what All Kinds Of Fur would say if she could tell her own story. A door opened when I began to study the contemporary poetics of erasure, the deliberate obscuring of selected words of a text to reveal new poetry composed of those words that remain. This form of visual poetry enabled me to show All Kinds Of Fur's own words rising out of the Grimms' text, and it set me on the path to discover just what this young heroine would say if her words could rise from where they lay hidden.

For me, the process of erasure has not been "What words should I erase?" but rather "What words rise?" Erasure offers me a chance to make visible and concrete a conversation—perhaps, even, an argument—between two texts. Through such a poem, rather than an essay, I can disagree with other interpretations of the tale as well as the assumptions of its translators. I can also create an alternative vision that presents the way a young woman, a survivor of abuse, would tell this tale. Word for word and sometimes syllable by syllable, *ALL KINDS OF FUR* points out what matters to its heroine—not the dresses, not the balls, not the wedding, but something else, something more. To heighten this conversation, I've kept the Grimms' tale present, but ghosted, on the page; Jen Bervin uses this same strategy in her erasure of Shakespeare's sonnets, *THE SONNETS OF WILLIAM SHAKE-SPEARE*. The work of Janet Holmes, Ronald Johnson, and Mary Ruefle illustrate other strategies of erasure: completely erasing or whiting out a source text. With the ghosted text present, though, All Kinds Of Fur's words continuously contradict the tale and the Grimms' words haunt the erasure.

As I wrote, I would choose a brief segment of the Grimms' tale that seemed to me a moment, a glimpse into the world of the tale; I put those words onto one page and changed the font color to gray. Then,

I'd look for words that All Kinds Of Fur might say and words that were available in the ghosted words of the Grimms. Sometimes the words I found helped me discover what the heroine might say. After that, I'd arrange the ghosted Grimms' text in lines, using ethnopoetic methods long practiced by poets, folklorists, and anthropologists to make visible the poetic nature of oral tales. Although the Grimms burnished their tales with literary language, I wanted to indicate that the oral tales they were based on resemble poetry more than prose fiction. The condensation of thought, the concentration of symbolic language, the allusiveness of what is and is not said, the use of repetition, the liveliness of the sonic, and the belief in the magic of words—I wanted the ethnopoetic lineation of the Grimms' text to show these oral, poetic watermarks of the tale.

Finding All Kinds Of Fur's story, though, was a challenge because the Grimms' tale that I knew so well kept tugging at me like a whisper at midnight, pulling me back toward the brothers' version, the brothers' vision. As I watched for words to rise, I repeated over and over—and sometimes out loud—my guiding questions: What would All Kinds Of Fur say? How does <u>her</u> story differ from the Grimms'?

Writing erasure with superimposed gray and black fonts enabled me not only to find her story but also to arrange the text as a contrapuntal movement between her and the Grimms. For example, in the cook's order to All Kinds Of Fur " 'but you must be back here' " (pp. 29/30), I found the word "steer": 'but you must be back here'. So, when All Kinds Of Fur speaks, she transforms someone else's idea of what she must do into a maxim that she, herself, lays down for her own future.

As I wrote, my eye was always on the ending. Would I discover how All Kinds Of Fur would "end" her tale? The young woman I was uncovering would not revel in a wedding, alone. And, how could I "end" her tale since I have long agreed with J.R.R. Tolkien and others that there is no "true end" to a story. Stories leave dangling, unresolved issues: what happens to the king, All Kind Of Fur's father, for example, in the Grimms' tale? And, more importantly, although stories come to a fullness—a satisfying resting place, their characters, events, and, most of all, the dilemmas they place before us linger in our thoughts and imaginations. Stories dramatize for us a crisis, a cultural dilemma—like a forced marriage to an unsuitable, unacceptable, wealthy, powerful person. As if watching a play, we follow characters as they decide what to do and what not to do. And, as we listen to the story, the story poses

83

its question: What would each one of us do?

So, as I began to write the last page of the poem, I stared at the gray source text and wrote in the margins the words I thought I might be able to use, words for All Kinds Of Fur to say. I found "I live I love," but that was too close to the Grimms' tale. Later, I saw that I could write "never ends a tale," but after a time, I discarded that: it was an idea that interests me; it couldn't be the heroine's last words. I kept revising.

Then, on another page, a word rose. While I was writing pages 67/68, I saw—truly saw, as if for the first time—the word "and." I realized that, at that moment, All Kinds Of Fur had on <u>both</u> a stunning ball gown <u>and</u> a mantle of all kinds of rough furs. She wore both; she was both.

From the process of erasure, from looking so closely at words and syllables, I was led to see All Kinds Of Fur in a startlingly new way, a way that felt immediately fitting, like a proper skin. And from my folklore studies, I knew, too, that seeing her as both human and animal fit, for stories about men and women who live in multiple skins are numerous, and beloved: folktales in the Grimm collection such as "The Singing, Springing Lark," "Bearskin," and "Goosegirl at the Spring"; other folktales such as "The Girl Who Married the Bear"; and legends from the northlands about selkies, the seal-people.

And so on the last page, All Kinds Of Fur sends us out from her story and into our own. Her transformation is not from dirty animal to beautiful woman but from a traumatized young woman who has, over the years, faced her abuse and has come to understand that she—and all people—are both animal and human, both scarred and beautiful. She realizes that shuttered hearts can open, love can be celebrated, and that marriages, even those of true minds, need always to be tended.

References

Atkinson, Jennifer. 2013. "Canticle of the Night Path." In *Canticle of the Night Path*. Anderson, SC: Parlor Press.

Beachy-Quick, Dan. 2006. "The Speaking Ear." *Boston Review*, 1 March. http://bostonreview.net/beachy-quick-the-speaking-ear-ronald-johnson-radi-os (Accessed 1/26/2016).

Bervin, Jen. 2006. *THE SONNETS OF WILLIAM SHAKESPEARE*. Brooklyn, NY: Ugly Duckling Presse.

Bottigheimer, Ruth. 1987. "Patterns of Speech." In *Grimms' Bad Girls & Bold Boys: The Moral & Social Vision of the Tales*, 51-56. New Haven: Yale University Press.

Elliott, Robert C. 1960. *The Power of Satire: Magic, Ritual, and Art*. Princeton: Princeton University Press.

Grimm, Jakob and Wilhelm. 1984. *Kinder- und Hausmärchen. Ausgabe Letzter Hand. Mit den Originalanmerkungen der Brüder Grimm. Mit einem Anhang sämtlicher nicht in allen Auflagen veröffentlicher Märchen und Herkunftsnachweisen*. Edited by Heinz Rölleke. Jubiläumsausgabe zum 200. Geburtstag der Brüder Grimm 1985/86 ed. 3 vols. Stuttgart: Philipp Reclam jun.
----------------------. 2003. *The Complete Fairy Tales of the Brothers Grimm*, 3ʳᵈ edition. Edited and Translated, with an Introduction by Jack Zipes. New York: Bantam.

Holmes, Janet. 2009. *THE POEMS OF EMILY DICKINSON*. Exeter, England: Shearsman.

Lopez, Barry. 1990. *Crow and Weasel*. San Francisco: North Point Press.

Jarvis, Shawn. 1993. Trivial Pursit? Women Deconstructing the Grimmian Model in the Kaffeterkreis. In *The Reception of Grimms' Fairy Tales*, 102-126. Edited by Donald Haase. Detroit: Wayne State University Press.

McClellan, Catharine. 1970. *The Girl Who Married the Bear*. Publications in Ethnology: 2. Ottawa: National Museums of Canada.

Paradiz, Valerie. 2005. *Clever Maids: How the Brothers Grimm Really Found Their Stories.* New York: Basic Books.

Rasmussen, Knud Johan Viktor. 1908. *The People of the Polar North.* London: Kegan Paul, Trench, Tubner. On Qilerniq and Greenlandic Inuit serrats [charms], p. 140. Digitized by University of Toronto, https://archive.org/details/peopleofpolarnor00rasmuoft (Accessed 8/15/2016).

Ruefle, Mary. 2006. *A Little White Shadow.* Seattle: Wave Press.

----------------------. 2010. "On Erasure." *Quarter After Eight.* Vol. 16. http://www.quarteraftereight.org/toc.html#on (Accessed 1/26/2016).

Scheub, Harold. 2002. *The Poem in the Story: Music, Poetry & Narrative.* Madison: University of Wisconsin Press.

Tatar, Maria, ed. 1999. *The Classic Fairy Tales: Texts, Criticism.* New York: W.W. Norton.

Tedlock, Dennis. (1975) 1991. "Learning to Listen: Oral History as Poetry." In *Envelopes of Sound: The Art of Oral History*, 2nd edition, 106-125. Edited by Ronald J. Grele. New York: Praeger.

Thomson, David. (1954) 2000. *The People of the Sea: A Journey in Search of the Seal Legend.* Introduction by Seamus Heaney. Washington DC: Counterpoint.

Tolkien, J.R.R. 1966. "On Fairy-Stories." In *The Tolkien Reader.* New York: Ballantine.

Yocom, Margaret R. 2013. "The Cinderella No One Knows: The Grimm Brothers' Tale of Incest, Fur, and Hidden Bodies," Botkin Lecture and Reading of "ALL KINDS OF FUR," Library of Congress, Washington, DC. Poem begins at minute marker #44: https://www.youtube.com/watch?v=BqnyVc4IOKY

----------------------. 2012. "But Who Are You, Really?": Ambiguous Bodies and Ambiguous Pronouns in "Allerleirauh." In *Transgressive Tales: Queering the Grimms*, 90-118. Edited by Kay Turner and Pauline Greenhill. Detroit: Wayne State University Press.

Acknowledgements

To my George Mason University colleagues, life-long gratitude: to Susan Tichy, friend and sister-traveler, in whose poetry seminars I learned of erasure and began *ALL KINDS OF FUR*; her x-ray comments on two versions of the entire manuscript and various orphan pages helped me find All Kinds Of Fur's voice. To Dr. Irmgard Wagner, Emerita, without whose tutoring in German I would never have been able to translate "*Allerleirauh*"; her wisdom and enthusiasm, her knowledge of German fairy tales led me through the prickly path of pronouns, 19th century German, and more. To Eric Pankey and my fellow students in his Heritage Poetry Workshop—especially Jen Daniels, Wade Fletcher, Alyse Knorr, Kevin Stoy, and Alison Straub—from whom I received invaluable critiques; to Jennifer Atkinson, who read and commented on this work with warmth and kindness. To my folklore colleagues, Dr. Debra Lattanzi Shutika and Dr. Joy Fraser who championed this folklore and creative writing project; to my folklore graduate students who cheered me on and offered wise counsel on fairy tales, especially Sara Cleto and Brittany Warman; to my folklore and poetry graduate students who served as graduate assistants to our Folklore Studies Program and helped with fairy tale research, and more: Shawn Flanagan, Paulina Guerrero, J. Michael Martinez, and Dr. Jennifer Spitulnik Hughes.

To writer-friends dear to me ever since we met in graduate school, many blessings: Robert H. Abel, Jr. (1941-2017) and Christopher Howell.

To my sisters of the heart—Ann Baker, Linda Dexter, Susan Gordon, Dr. Joan Radner, and Rev. Dr. Eileen Sypher, thanks beyond measure for accompanying me on the journey.

To my editor Jeff Haste of Deerbrook Editions: many thanks for helping All Kinds Of Fur tell her own story.

Finally, always and forever, to my husband, Dr. John Slack, whose loving support is the pearl of great price.

About the Author

Margaret Yocom grew up in the Pennsylvania German farmland listening to her grandparents' stories. Her poetry has appeared in the *Beloit Poetry Journal*, the anthology *The Folklore Muse: Poetry, Fiction, and Other Reflections by Folklorists*, and elsewhere. She founded the Folklore Studies Program of George Mason University where she taught for 36 years; among her many courses, she offered "Living Words: Folklore and Creative Writing." She has published on the Brothers Grimm, on the folk arts of political protest, on Inuit storytelling in northwest Alaska, on family folklore, and on the folk arts of Maine logging communities. Co-founder of the American Folklore Society's Creative Writing and Storytelling Section, she holds a Ph.D. in English and folklore from the University of Massachusetts at Amherst. A founding member of Western Maine Storytelling, she tells legendary tales of the seen—and the unseen. Co-organizer of the Hugh Ogden Memorial Evening of Poetry, she makes her home with her geologist husband, John Slack, in the western mountains of Maine. http://margaretyocom.com

In these poems, Margaret Yocom offers a new vision of Jakob and Wilhelm Grimm's controversial "Allerleirauh" ("All Kinds Of Fur"), a lesser-known version of "Cinderella" that opens with incest. Erasing the Grimms' words to reveal a young woman's story of her journey to a new, full life, Yocom asks, What would All Kinds Of Fur say if she could tell her own tale? In *ALL **KINDS** OF **FUR***, the heroine's words rise.